Journey Into Renewal

Brian Bigelow

Journey Into Renewal
by Brian Bigelow

ISBN-13: 978-1469917443
ISBN-10: 1469917440

Copyright © 2012 by Brian Bigelow

Soul sense published in "The Colors of Life"
by The International Library of Poetry ©2003 Brian Bigelow

Time Flight published in
"The International Who's Who In Poetry"
by The International Library of Poetry ©2004 Brian Bigelow

Passages previously published in
"The International Who's Who In Poetry"
by The International Library of Poetry ©2005 Brian Bigelow

Photo with The gateway ©2011
Published as the front cover of "Get The Job"

ALL RIGHTS RESERVED. No part of this work covered by the copyright herein may be reproduced by any means without written permission.

This book is dedicated to two women,
Patricia and Brandy.
It wouldn't have been possible otherwise.

Contents

Introduction	1
Cycle of life	3
Animate	4
Time passages	5
Season of change	6
Ancient ones	7
Distant reaches	8
Of wind and wolf	9
Time of rest	10
Enchanted moment	11
Spirit guide	11
Goddess dance	12
Sweet miracle	13
Dancing away	14
Star goddess	14
Echo's	15
Waiting for Spring	16
Spirit dance	17
Daybreak	17
Dancing away	18
Dawn light	19
Afterglow	20
Spirit guide	21
Visit	21
Life and love	22
Monsoon	23
Rainforest	25
Journey to freedom	26
Open roads	27
Life becoming art	28
The gateway	29
Becoming whole	30

Soul sense	31
Time flight	32
Passages	33
Falling leaves	34
Towards the light	35
Snowfall	36
Light of life	37

Introduction

In March 2002, my first wife, Patricia passed away and it seemed for a while as if my life had came to an abrupt end. It was the beginning of a time where it felt like I became totally empty and that I had reached the end of my existence. For the next four months I tried to figure out how to start living once again and in the process discovered both photography and poetry. For some, like myself, I think that it takes great sorrow and loss to become transformed. I can't say now that I was living before all this happened.

At first, the poetry was kind of a way to communicate with Trish and the photography was just a bit of a hobby and a way to take things off of my mind. Over the next couple of years both hobbies allowed me to delve into myself and begin to exorcise the inner demons that I had allowed to control my life. By June 2004 I had even begun to like myself for the very first time in my life.

My present wife, Brandy is who really deserves kudos for the way that she has supported me in this endeavor. I am so glad that I have found her and that she is now in both my life and my heart. She really has been one of the best things to ever happen to me. Without her caring, encouragement and love this book would have never been possible.

From a great tragedy
An awakening begins

From the tortured spirit
An opening within

a...

Journey into renewal...

Brian Bigelow

Cycle of life

Tree upon the mountainside
Locked in its world of white
Branches so naked and empty
Waiting for the warmth to come
Time rotating in coiled spiral
Coming back to bring renewal
Eternal dance of season's passage
With light and life mingling there
While the tree waits in silence
For life to begin once more
Under the vast expanse of sky
12/5/04

Animate

Dancing with the goddess
Under the pale moonlight
My spirit becomes freer
Able to reach for the heights
Soul begins to animate
Undulate with the moon
While he singing begins
Drawing me into her tune
Expanding my spirit
With her sense of being
My sister spirit comes to me
Opens up what I am seeing
And the world that awaits
Her special nature within
Consorting with my spirit
Peaceful voice calling in
3/25/05

Time Passages

Time in a spiral around me
Elements of you in what I see
Walls coming down all around me
Allowing me to finally see
Missing part of my soul in need
Towards new ends my heart always leads
Dancing always in the distance
A vision out of reach seems to prance
Reaching out my spirit today
To touch a projection on the way
On enchanted twilight journey's
Where I am always seeking to be
Essence of every single want
Every element it seems to haunt
Extends out beyond my essence
Seeking to coalesce with that presence
Passages of time come and go
While I seek what I wish to know
Letting my mind begin to grow
With my emotions beginning to flow
9/5/04

Season of change

My spirit so empty
Since that fateful day came
Ending of reality
Tossed about in the waves
Moments came and went by
Past I cherished to save
So slowly life returns
While flowing through time
As life wends through the turns
10/29/04

Ancient Ones

In the darkened valley
Whispering in the night
Those ancient sentinels
Shadows in pale light
Looking bent and twisted
Aged beyond their years
As I sit and listen
With the path so near
Sitting there listening
To the low communion
Carried by the breezes
And shadows of ebon
After a moment more
My thoughts begin to speak
Commune with the darkness
For the wisdom I seek
7/22/06

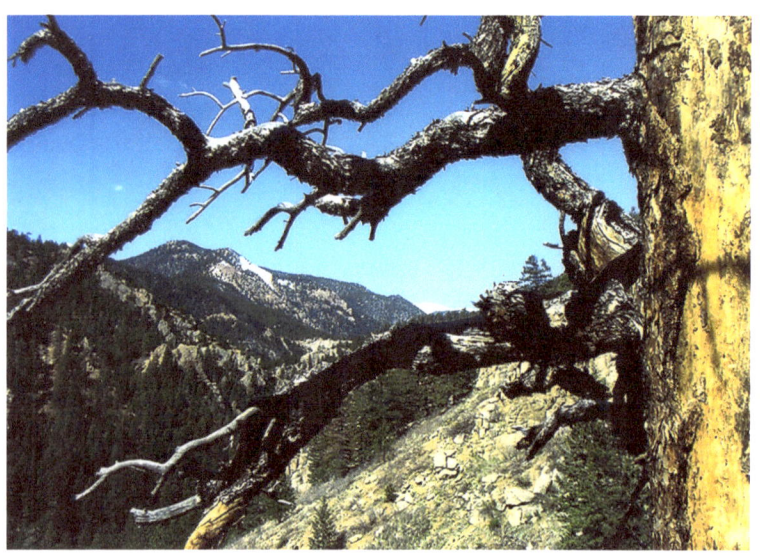

Distant reaches

This distance seems so far
When I want to touch you
Wish upon falling stars
Trying to make it through
My thoughts are always there
Walking with you each day
A vision I'm aware
Within my mind to stay
Reaching out my spirit
The distance becomes short
Want to do every bit
Helping you reach the port
Passages of time extend
Seems I sometimes can't wait
As the road seems to wend
Towards eventual fate
9/25/04

Of wind and wolf

Breeze descending on the scene
Clouds and trees begin to move
Caught up in the esoteric dance
As the wolf comes out of hiding
Full moon shining in its display
Calling out to innermost longings
Bringing out the wolf's haunting howl
Speaking to a deep secret yearning
Visions appearing within the mind
While shadows and dream conspire
Interplay in the passages of time
Carried beyond the glowing orb
By the drifting of passing thoughts
12/12/04

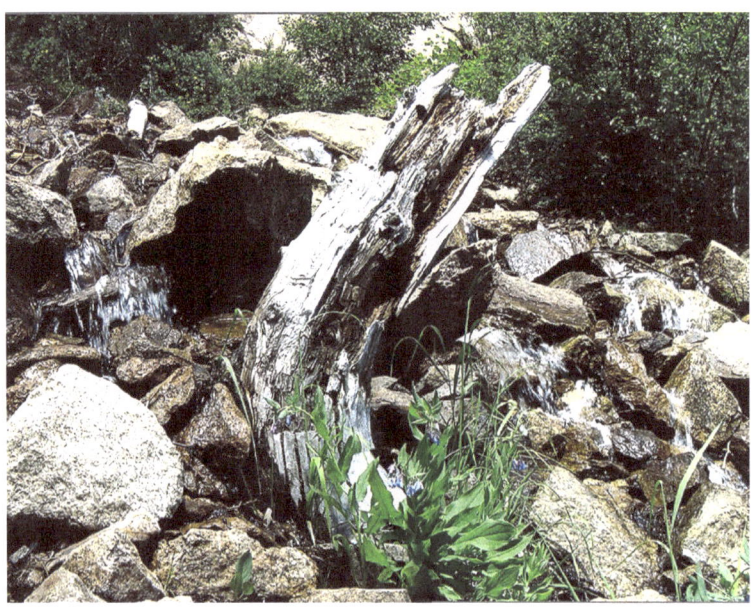

Time of rest

World of white waiting in patience
While time passes towards renewal
Icy tendrils grasping all within reach
With the crystals that slowly fall
Adding to the blanket that covers
And the wonderland that gently calls
12/23/04

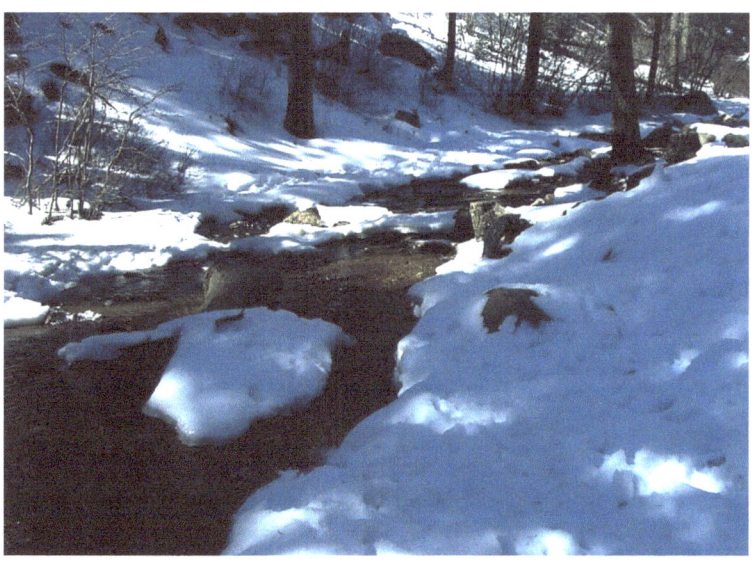

Enchanted moment

Pale orb lights a winding path
Shadows within ebon hues
Under the twinkling lights
Flickering as if on cue
All is becoming quiet
Time lost within the moment
Lost both in time and place
Thoughts start to become silent
Bringing a time of healing
Freeing of a souls essence
To move upon the breezes
Moved by the glowing presence
1/20/05

Spirit Guide

Dreams and desire dance in the night
Under passage of falling moonlight
She reaches down deep into my soul
Guiding me around the many shoals
Toward the coming of a new dawn
Listening for the seas endless song
Beyond the reaches of my life's past
Into my soul her image is cast
Guiding light into the coming age
To be written upon a blank page
10/17/04

Goddess dance

The goddess in the garden
Opening contorted souls
Reaching from the denizens
An effort to become whole
Joining with her essence there
Spirit intertwines within
Into the future to stare
Beyond the seas constant din
Emotion becoming essence
With the dancing in the dark
Part of her changing presence
Passing time within the park
10/10/04

Sweet miracle

Clouds passing by in the night
Moon hidden with its cold light
Tide was moving me further
No footing I could acquire
Until the guide came to me
Opened my eyes there to see
Took hold of the hand offered
Into the light I was led
Set free there from the water
And places it would saunter
Sweet miracle of new life
Finally been made alive
In the new life I'm given
New realm in which I'm living
12/7/04

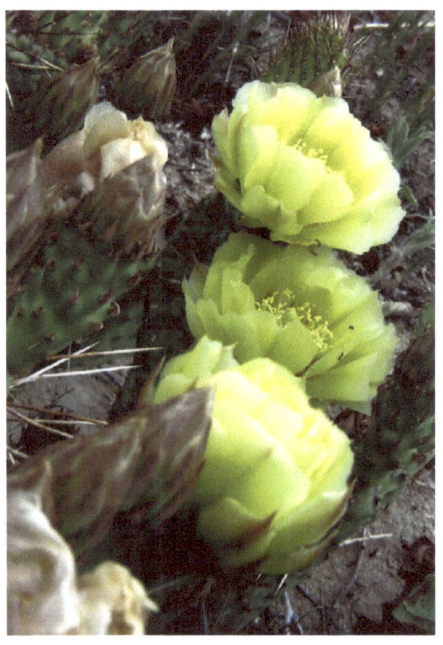

Dancing away

Feeling the colors
As they pass on through
Take hold the burden
Time becoming new
Entering freedom
When all time has come
World of the dreams
The spirit at play
All colors in dance
One wishing to stay
Reaching far beyond
Bursting into song
11/13/06

Star goddess

Looking down to where I am
I see the special essence
Guide of lifetimes passage
And I feel her presence
From her place among the stars
Where they flicker endlessly
Myriad worlds shining
Sending out their light nightly
9/8/06

Echo's

Echo's of the forest come to mind
Each time I hear the song again
Wind blowing through the leaves
Stream flowing beyond this place
Moments that live in my soul
Dreams carrying me far beyond
Lost in the realm of this presence
Seeing the beauty of the moment
Capturing it within my dreams
Passing into that state of grace
Where I become whole again
12/26/04

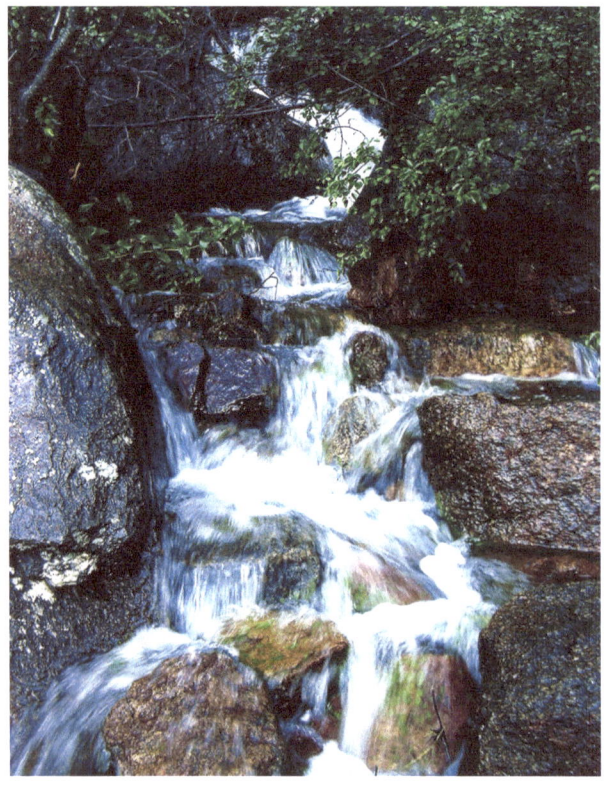

Waiting for spring

Blanket of faceted crystals
Glistening in a festival
Covering the world in white
Clouds bring the palest light
Shortened days bringing renewal
To the child within it calls
World of wonder in the cold
Upon all children it takes hold
1/5/05

Spirit dance

Spirits dancing in my vision
Guiding me into the realm
Dreamscape extending beyond
While the dance commences
In an immortal embrace
Lost in the passage of time
Shadows move and twist within
Becoming one with the spirits
Intertwining with my soul
Dancing with the fallen darkness
Until the light becomes life again
11/27/04

Daybreak

Opening of my heart
Life beginning to start
Reaching beyond the sea
A heart the yearned to be free
The books open pages
Life starting a new stage
Daybreak now reaching me
Letting me know I'm free
New spirit lives inside
Darkness moving aside
12/2/04

Dancing away

Feeling the colors
As they pass on through
Take hold the burden
Time becoming new
Entering freedom
When all time has come
World of the dreams
The spirit at play
All colors in dance
One wishing to stay
Reaching far beyond
Bursting into song
11/13/06

Dawn Light

Sunrise breaking the surface
Colors dance on the horizon
So much to discover now
Riding on the winds of fortune
Moments to revel within
Light flooding through every pore
Lost in the awakening
Brought with the daily encore
1/19/05

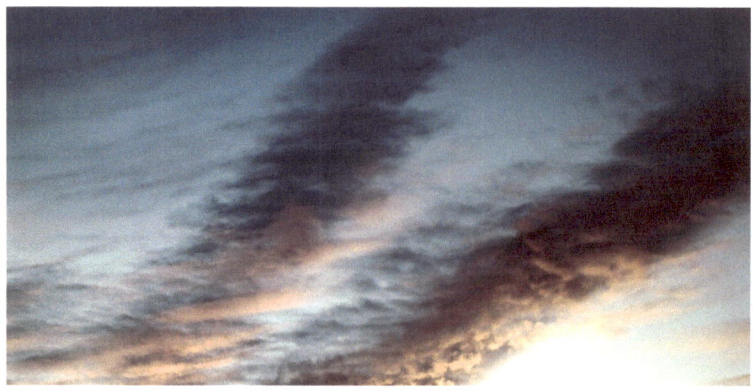

Afterglow

Morning of passions embrace
Where two hearts began to race
As souls intertwined together
Became lost within each other
Until nothing else around exists
Lost into the enveloping mists
Wrapped up within the comfort
Coming from the mornings effort
Opened up to every to every sensation
During such beautiful passion
While we lay here together
Two aware only of each other
Lost within the sweet afterglow
Emanating from passions flow

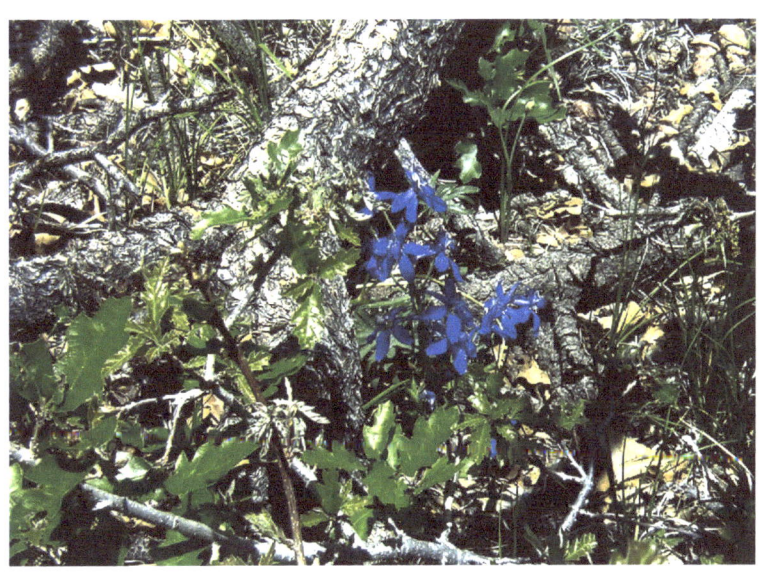

Spirit Guide

Dreams and desire dance in the night
Under passage of falling moonlight
She reaches down deep into my soul
Guiding me around the many shoals
Toward the coming of a new dawn
Listening for the seas endless song
Beyond the reaches of my life's past
Into my soul her image is cast
Guiding light into the coming age
To be written upon a blank page
10/17/04

Visit

Special friend comes to visit
Time lost in the passage
Hours seem to disappear
Within the moments closeness
Lost in the spirit's embrace
State of grace descends
Coming with a special touch
That only a good friend brings
With the passage of time
1/18/05

Life and love

Mountain trails beside cascading streams
Visions that in my mind dances and teems
Moving with a life becoming art
Life, love and peace ruling within my heart
As my spirit reaches for open skies
To where all my future vistas now lie

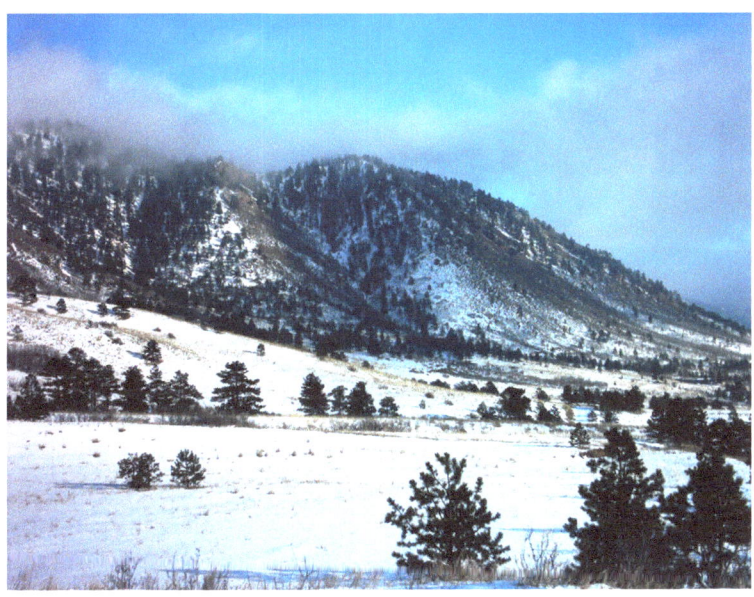

Monsoon

Rain coming to fall around
As I get lost in the sound
Falling drops begin to pound
New life in my soul is found
Time in its moving spiral
Brings me to survival
My spirit opening wide
Nothing within that can hide
With the raindrops all about
To my soul the moment shouts
Whole world in wet presence
Brought the nature of essence
Moments that speaks within me
Cause my spirit to be free
Sets me on the course I want
Far beyond the oldest haunts
State of renewal begins
New life beginning to win
In this change of season
Soon to bring the shining sun
Open the spirit to see
Where I really wish to be
Soaring into the future
Emotion flowing so pure
Monsoon bringing the beauty
Along with new realities
4/4/05

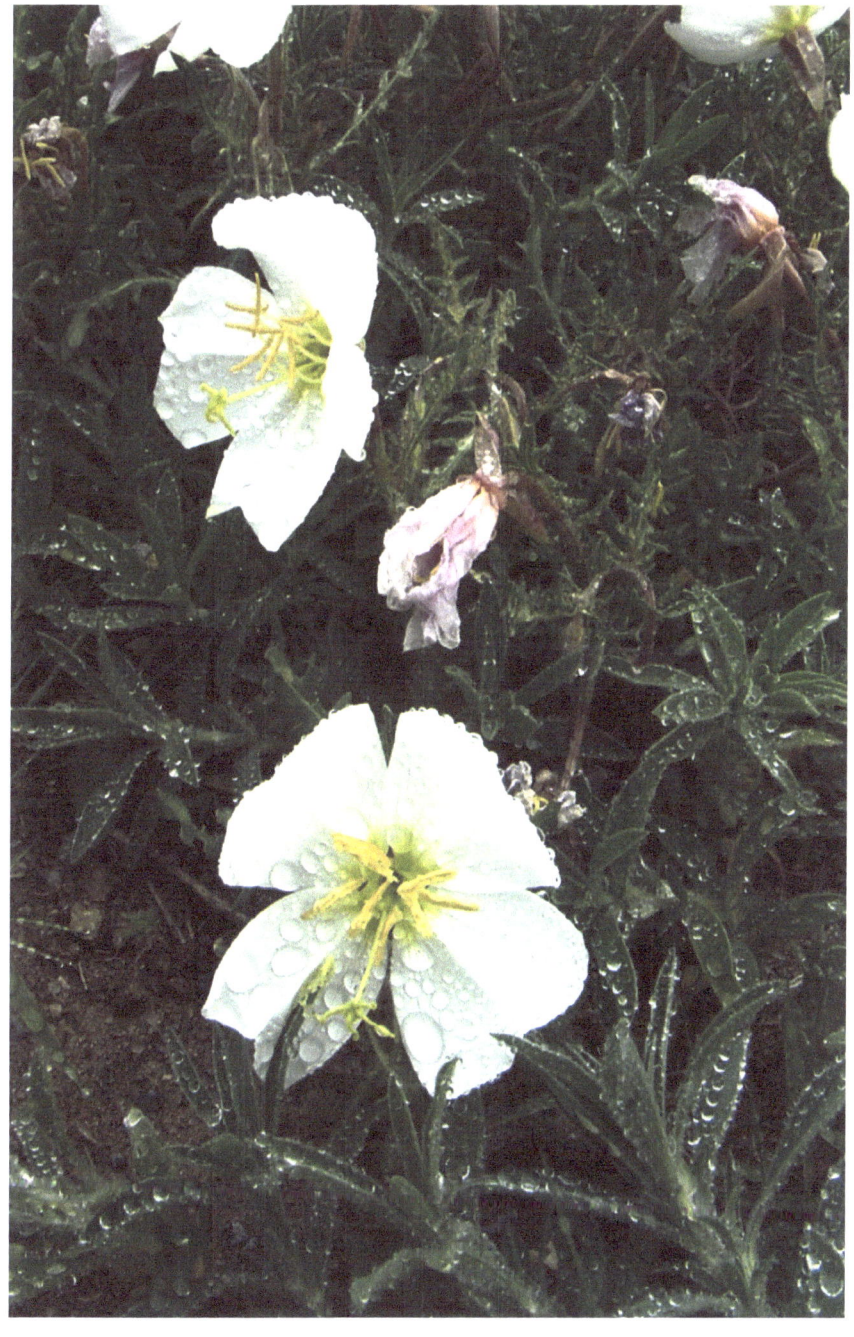

Rainforest

Rain begins to fall on the forest
Deluge becoming a torrent
Colors blending into pastels
As the forest begins to drink
Gathering to begin anew
To bring the new life within
Time continuing in its spiral
Light and life conjoining
Where beauty can be beheld
Entering to enfold the spirit
New life beginning to grow
Opening the door to the soul
Moment caught in time there
Memory to relive the essence
When the sun renews its light
Chases away the monsoon
To bring the cycle full circle
Growth for the inner being
With the cycle of a whole life
4/10/05

Journey to freedom

Restless spirit beginning its flight
Ready to reach for the highest heights
Whole world in revolution below
With the restless spirit on the go
Soaring high above the heavens high
Reaching far into the endless sky
Soul and spirit opening further
Target in sight the spirit acquires
Ambitions to bring the guidance in
While on the journey far within
New realms to be reached with the moment
Carried upon the essence of the scent
4/5/05

Open roads

Black ribbon stretching out
Calling out with its freedom
To take me on the journey
Where so much is waiting
Sunsets, mountains and streams
Rain, fog, snow and wind
And so many new friends
Building a life within
Each moment we touch
Energizing the essence
Setting free the spirit
While opening the soul
Letting in all of the light
Shadows to fade away
Wings begin to spread
4/27/05

Life becoming art

Colors all beginning now together
In the bright early changing light
Bringing new wonder to live within
As a spirit is taking its first flight
Renewal to start on this journey
Time winding in its spiral passage
Light beginning to flow on through
Captured there within the image
Soon etched deep into a memory
Adding to that life's full vision
Calling from deep within the soul
While entering into the passion
Brought within the beauty there
Changing the color of the heart
With the opening of the windows
To flow on through into the art
While the beauty starts enfolding
Becomes part of the inner essence
Traveling on this visual journey
Under the golden orbs presence
5/9/05

The gateway

This long journey into the future
That has brought memories to treasure
Long ago there opened a gateway
To places far off the pathway
Once the gateway was standing open
Discovery began to beckon
7/21/06

Becoming whole

New vistas awaits us if we just reach outside
To bring the beauty within our souls
Passages in time as we flow along the river
Becoming entities that are a whole
2004

Soul sense

A city calls out to me
From beyond an endless sea
Through both time and space
Heart beginning to race
Once a hidden element
Caught in the sudden moment

A world beyond my reach
Yet a lesson to teach
Images coalesce and mingle
Senses beginning to tingle
Of the hidden entity within
Caught in the sudden din

A chorus of sound calling
Thoughts kept in their hiding
Beyond the realm of vision
Soul beginning on a mission
Hidden deeply for so long
Until caught up in the song
2003

Time flight

Breeze blowing through an open window
Music from the speaker starts to flow
As I'm lost within this moment here
Essence calling from beyond the years
Where mood and emotion become one
Spirit reaching high into the sun
Flying across an expanse of sky
Time always calling me as it flies
Whole world begins to disappear
In a moment of ecstasy brought near
Time in circular spiral movement
Brings me back to where I have been sent
Until I become lost once again
Moment that one would wish wouldn't end
2004

Passages

Walking with the shadows of the night
She reaches into my dreams on passing light
Dancer on the edge of dreams as I sleep
Where I reside in the castle's hidden keep
Wishes and dreams become entity
As my soul once again seeks to be free

Taking her hand each time I travel now
On a passage into the evenings' flow
My essence caught up in the nightly vision
Calling out to my life's simple passion
Joining once again with another soul
Once again seeking to be a whole
2005

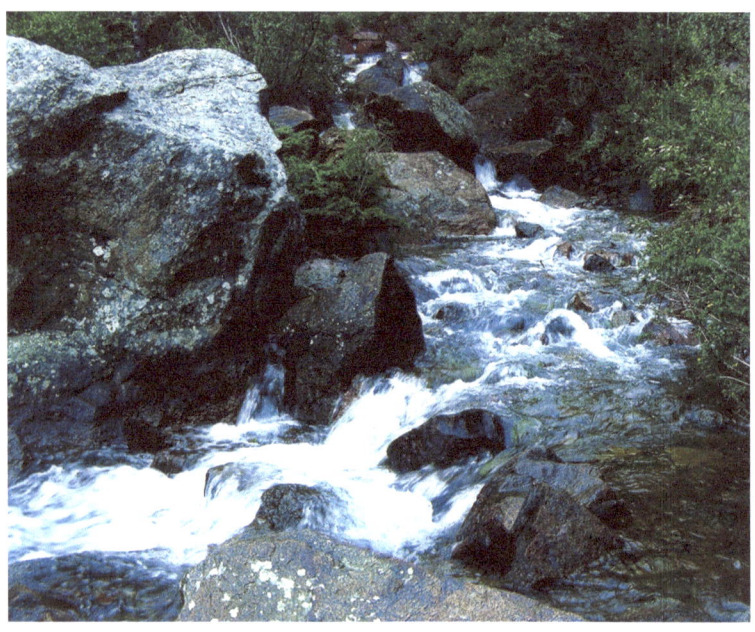

Falling leaves

Leaves falling all around
In the passage of season
Colors in a symphony
Flooding the soul within
Green turns to gold and red
Branches soon to be barren
With descent of the cold
Time dances in a spiral
Once again to visit us
Essence of time eternal
Wrapping the spirits in color
10/26/04

Towards the light

Spirit soaring across the sky
Stars shining bright while I fly
Gentle friends showing the way
Toward the dawning of a new day
Light shining in the darkest night
Bringing life to the hidden sight
Long dormant within my essence
Awakened with this nightly dance
Partaking of the astral flow
Where seeds planted deep start to grow
Inner beauty starts to emerge
Passions within begin to surge
Guiding me on far flung journeys
Traveling beyond endless seas
2/24/05

Snowfall

Covering so extensive
In a colorless blanket
Deepening with the descent
As icy fingers are clawing
Begin to cling and grasp
Penetrating all so deeply
While the pulse quickens
Spirit being urged onward
All while a little child
Visits worlds of dreams
Sleeps in pleasant warmth
Far from the cold outside
With its expanse of white
11/30/06

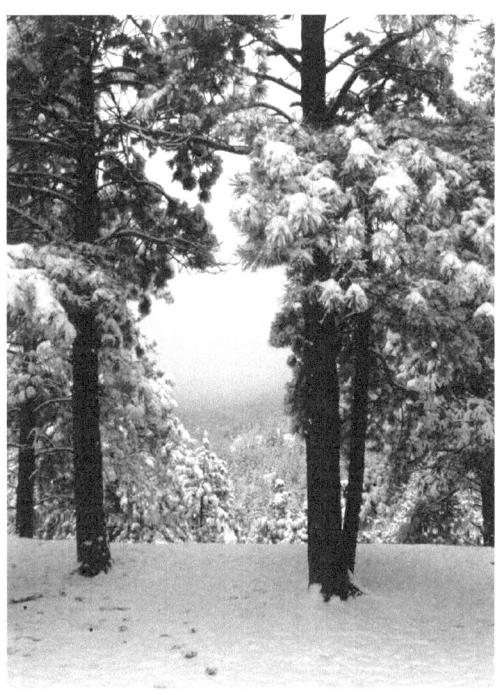

Light of life

She walks along on the shadows of night
Bringing into my life new dawning light
Essence of everything I wish to be
Touches what was cold and dead within me
Letting in the light that shines through time
Etching upon my soul a new found sign
Opening up of the walls around about
Visions no longer to be held out
A world now reaches into my soul
Someday maybe I will finally be whole
No longer delving into the darkness
Tearing down every single inner fence
Love conquers all in a soul in turmoil
And a head caught in the waters roil
I open my hand to touch her power
Never to close the book on budding flowers
New life exists within my searching heart
Something that I want always to be a part

9/14/04

www.ingramcontent.com/pod-product-compliance
Lightning Source LLC
Chambersburg PA
CBHW041114180526
45172CB00001B/241